© Universal City Studios LLC.
All Rights Reserved.

INSIGHTS insighteditions.com

MANUFACTURED IN CHINA 10 9 8 7 6 5 4 3 2 1